by

Robert Elwall

© Royal Institute of British Architects 2000

Published by RIBA Publications
Construction House, 56-64 Leonard Street, London, EC2A 4LT

ISBN 1-85946-083-6

Product code: 21003

The right of Robert Elwall to be identified as the Author of this work has been asserted by him in accordance with the Copyright, Designs and Patents Act 1988.

Publisher: Mark Lane
Editor: Matthew Thompson
Commissioning Editor: Matthew Thompson
Design and typography by Red Hot Media, Suffolk
Printed and bound by Dennis Barber Graphics & Print, Suffolk

ARCHITECTURE IN CAMERA

Eric de Maré

Images from the Photographs Collection
of the
Royal Institute of British Architects

by
Robert Elwall

Table of Contents

Foreword

The RIBA Library Photographs Collection, containing over 650,000 images of architecture and related topics world-wide, is one of the most extensive and important in its subject field. The Collection's earliest images date from the Great Exhibition of 1851 and it includes the work of internationally renowned photographers such as Edouard Baldus, Francis Bedford and Tony Ray-Jones, as well as that of respected professional architectural photographers, among them Bedford Lemere, Dell & Wainwright, and Sydney Newbery. In addition the Collection holds the archives of several of Britain's foremost twentieth-century architectural photographers such as John Maltby, Colin Westwood, John McCann, Henk Snoek and Alastair Hunter. The aim of this series of books is to make the Collection's riches better known and accessible to a wider audience. If you would like copies of any of the images featured or you are seeking a particular picture please do not hesitate to contact us. The Collection is available to all. Similarly if you know of photographs you think might suitably be lodged in our Collection and thus preserved for the benefit of future generations we would be delighted to hear from you.

The Collection's holdings of work by Eric de Maré consist primarily of the 1,600 negatives acquired from him in 1991. These include classic images as well as variant and unpublished views. The same images by de Maré were often published at different times

in slightly different versions and here the decision has been taken to reproduce the whole of each negative. In the absence of any firm documentation the dates given for the photographs can only be approximate, being based on de Maré's publications and other sources.

I am grateful to Eric de Maré; to Mark Lane and Matthew Thompson at RIBA Publications; to A. C. Cooper (Colour) Ltd for copy photography and printing; to Andrew Mead of the *Architects' Journal* for supplying the portrait on the back cover by Phil Starling; but above all, as always, to my wife, Cathy.

Robert Elwall
Photographs Curator

Introduction

In 1972 Eric de Maré wrote, *'The photographer is perhaps the best architectural critic, for by felicitous framing and selection he can communicate direct and powerful comments both in praise and protest. He can also discover and reveal architecture where none was intended by creating abstract compositions of an architectonic quality – perhaps from a ruined wall, an old motor car, or a pile of box lids'*[1]. These words could well serve as a fitting summing-up of de Maré's own long and distinguished career in architectural photography. His photographs not only embraced a wide range of subject matter, from Britain's industrial and architectural heritage through to the architecture of foreign lands and the work of contemporary practitioners but also gained wide currency through their reproduction both in the professional and more general press. In addition, he was a prolific author writing over 20 books, including the immensely popular Penguin *Photography* (1957), which ran to seven editions, and *Photography and Architecture* (1961), which still remains one of the most penetrating analyses of the subject.

Underpinned by a political radicalism enshrined in his life-long espousal of the doctrine of social credit and a determination to redress what he regarded as the impoverishment of visual culture, de Maré's writings and photography, though profoundly humanistic, are imbued with a quality of almost missionary fervour that led Sir Hugh Casson to describe him as a *'crusader'*. That his

[1] Eric de Maré, 'Eric de Maré', *Art Without Boundaries: 1950–1970*, ed. Gerald Woods et al. (London: Thames & Hudson, 1972), p. 100

images made a telling contribution to the post-war reassessment of Modernism, greatly broadened the perception of where 'architecture' was to be found, and gave a new respectability to architectural photography by extending its influence beyond the narrow confines of professional discourse, are factors which together have cemented de Maré's reputation as one of Britain's most important and influential architectural photographers.

Eric de Maré was born in Enfield in 1910 of Huguenot descent. His parents, however, were Swedish and this connection was to remain an important influence. He first visited his parents' homeland at the age of seven, briefly attended a state school there, and was to make frequent return trips. From 1928 to 1933 he studied at the Architectural Association and after graduating spent a short spell in an architect's office in Stockholm before joining the Architectural Press, where he became acting editor of the *Architects' Journal* in 1943. Despite leaving after four years to become a freelance writer and photographer, he retained close links with what he termed his *'old alma mater'*. He remained a frequent contributor both to the *Architects' Journal* and more especially its sister magazine, the *Architectural Review,* and continued to share many of their major editorial concerns. De Maré celebrated his new-found freedom by taking his wife and camera on a hazardous canoe trip from Gothenburg to Stockholm. He had been taking photographs ever since being

given a box brownie camera on his tenth birthday and no doubt would have been encouraged by the example of F. R. Yerbury, the A.A.'s secretary, whose photographs (used to illustrate a series of picture books and articles in the *Architect & Building News* by the school's Principal, Howard Robertson) did much to bring continental Modernism to the notice of British architects and students of the period. De Maré greatly admired Yerbury's work as he did that of Dell & Wainwright, the *Architectural Review's* official photographers from 1930 to 1946, which he rightly acknowledged *'helped to establish the modern movement (such as it is) in this country'* [2]. His own first published photograph appears to have been a Cordoba roofscape contributed to the annual exhibition of A.A. members' photographs and subsequently reproduced in its house journal in 1933 [3].

Although after the War the determination to start afresh and build a brave new world saw Modernism in the ascendancy for the first time, debate raged fiercely as to its nature and the best way forward. In 1948 de Maré made a significant intervention with the publication of an article in the *Architectural Review* entitled *'The New Empiricism: the Antecedents and Origins of Sweden's Latest Style'* [4]. De Maré argued that Sweden was entering a new phase in its architectural development characterized by a reaction against the overly rigid formalism of the International Style in favour of a *'return to workaday common sense'* [5]. In practical terms this entailed

[2] Eric de Maré, *Photography and Architecture* (London: Architectural Press, 1961), p. 17

[3] *Architectural Association Journal*, vol. 48, Mar. 1933, p. 282. The AA has an outstanding archive of de Maré material.

[4] *Architectural Review*, vol. 103, Jan. 1948, pp. 9–22

[5] *Ibid.*, p. 9

freer planning and fenestration; a greater use, where appropriate, of indigenous traditional materials; an enhanced sensitivity to site and landscape; a return to 'cosiness' in domestic architecture; and a recognition of the importance of psychology in design. What appealed to de Maré most of all was that 'the New Empiricism' represented a more humane form of Modernism and as such was also dubbed 'the New Humanism'. The article, which amplified another penned in the previous year by the Review's proprietor Hubert de Cronin Hastings[6], struck a resonant chord. For architects faced with the problem of creating an architecture suited to the requirements of the nascent Welfare State, Sweden, with its wide-ranging welfare facilities and state provision of low-cost housing, afforded an obvious role model. In addition, for the generation of architects trained before the War the lure of Sweden was already strong, particularly following Gunnar Asplund's designs for the Exhibition of Modern Industrial and Decorative Arts in Stockholm (1930), which were widely admired. De Maré continued to extol the merits of Swedish architecture in two further publications, Scandinavia: Sweden, Denmark and Norway published by Batsford in 1952, which contained many of his own photographs 'so that text and pictures here integrate to an unusual degree'[7], and a slim monograph, Gunnar Asplund (1955). In the same year the Architects' Journal could justifiably claim that de Maré was 'one of our foremost authorities on Swedish architecture, and by his writings and brilliant photography has played a part in extending the

[6] Architectural Review, vol. 101, June 1947, pp. 199–204

[7] Eric de Maré, Scandinavia: Sweden, Denmark and Norway (London: B. T. Batsford, 1952), front flap of dust jacket

influence of Swedish design over modern architecture in Britain'[8]. This influence, which extended to the Hertfordshire County Council's pioneering school building programme and the architecture of the New Towns, was most evident at the *Festival of Britain* (1951) and in the Festival style that subsequently swept the country as the publicly acceptable face of Modernism. De Maré himself did not wholly approve. Writing in 1955, he compared the Festival unfavourably to the Stockholm exhibition of 1930:

'The South Bank was certainly of the greatest value in popularizing the new architecture, just as the Stockholm Exhibition had been. But the South Bank was less of a vitalizing innovation; it had less unity and was less functional, for whereas Asplund deliberately sought to make his buildings act as simple frames or boxes for the display of the exhibits themselves, the South Bank montage tended to swamp the exhibits and thus to some extent to defeat its object'.

He then added in a passage with which the *Architectural Review* would have heartily concurred and which reflected one of the major concerns of his photography, townscape:

'One important feature, however, both exhibitions had in common — the imaginative creation of a whole new environment, of a new urban landscape, as a sample of the modern town as it might become if we willed it — not squalid, monotonous and chaotic as most towns

[8] *Architects' Journal*, vol. 121, 20 Jan. 1955, p. 101

are today, but fresh, gay, ethereal, exciting and unified by a common idiom' [9].

By the time these words were written however the architectural landscape in Britain was changing and Scandinavian influence was beginning to wane. As if in confirmation of this fact, de Maré's report of a return visit to Sweden in 1955 in the *Architects' Journal* sadly admitted that the New Empiricism *'has not crystallized clearly and the formal trend is uncertain'* [10]. Ironically, it was de Maré himself who was to provide the raw material that helped to accelerate this transformation in British architecture.

In July 1949 de Maré had been responsible for a special issue of the *Architectural Review* on canals that was reissued in book form by the Architectural Press in the following year. De Maré wrote the text and supplied the overwhelming majority of the photographs that he had mostly taken in 1948 during a 600-mile trip from London to Llangollen and back surveying a dozen canals. *'The camera has tried'*, de Maré wrote, *'especially to capture the superb sculptural forms, textural patterns, and the occasional drama of the canal vernacular, whether this is expressed in an intimate lengthman's cottage, a grand Telford aqueduct, the gearing of a lock paddle, or the entrance to a tunnel with its sinister intimations of a John Martin hell within'* [11]. This aim was triumphantly realised in a series of striking photographs which, in their fond depiction of

[9] Eric de Maré, *Gunnar Asplund: a Great Modern Architect* (London: Art & Technics, 1955), p. 31
[10] *Architects' Journal*, vol. 121, 20 Jan. 1955, p. 101
[11] Eric de Maré, *The Canals of England* (London: Architectural Press, 1950), p. 12

unselfconscious craftsmanship and humble objects such as the bollard which he hailed as *'Sculpture by Accident'* [12] *(fig. 18)*, fully revealed the hypnotically suggestive power of de Maré's imagery for the first time. Although the ostensible purpose of the issue was to document structures that were in danger of disappearing as a result of the 1948 nationalisation of the canals, de Maré was anxious to underline the lesson these anonymous vernacular structures afforded to contemporary architects:

'Throughout the history of English – or for that matter of any other – architecture, there is a continuous thread running parallel with the historical styles but owing little or nothing to them. It might be called a timeless tradition of functionalism if the term had not become confused by being used to define a far more sophisticated phase of contemporary architecture. For its constituent elements are geometry unadorned, and it owes its effects to the forthright, spare and logical use of materials. To this extent it has affinities with the architectural effects sought by the architects of to-day, which no doubt explains why, looking back over the centuries, our own eyes are especially apt at picking out structures that owe their charm and quality to this tradition of functionalism' [13].

For de Maré the English canal system represented the best place to study what he termed *'the functional tradition'.* It was to prove a resonant appellation and a subject that de Maré and the

[12] Eric de Maré, *The Canals of England* (London: Architectural Press, 1950), p.95
[13] *Ibid.,* p. 42

Architectural Press were to explore more fully to increasingly influential effect over the coming years.

The *Architectural Review* took up the theme again in January 1950 with an issue entitled *'The Functional Tradition'* that broadened the subject by featuring elements such as street furniture, lettering and railway equipment and relating it directly to what was to become one of the *Review*'s most pressing preoccupations of the decade – townscape. Despite de Maré's sharing of these interests, rather surprisingly his contribution was restricted to the reproduction of 18 of his photographs and the issue was very much the brainchild of Hastings and its editor Jim Richards. Although its focus was wider, de Maré's own next involvement with the functional tradition came with his *Bridges of Britain* published by Batsford in 1954, where de Maré's concerns with textures, patterns, repetitive rhythms, solidity and mass came to the fore once again. Here de Maré argued that, apart from the bridges of the Renaissance and the eighteenth century whose ornamentation was well integrated with their structure, most bridges had no need of such embellishment as they had *'one uncompromising function – a limitation that makes for purity of form, a purity that can reach beyond practical prosiness to the poetry of structure'* [14].

This 'poetry of structure' was to be most persuasively exhibited in the photographs de Maré took in 1956 as a result of a roving

[14] Eric de Maré, *Bridges of Britain*, 2nd Edn (London: B. T. Batsford, 1975), p. 7

commission given to him by Richards and the staff at the *Architectural Review*. De Maré's task was to document the buildings of the Industrial Revolution – warehouses, docks, naval dockyards, textile factories, water-mills, windmills, breweries, sheds and bridges – *'whose architectural virtues'*, Richards maintained, *'have not yet been fully recognized'* [15] *(figs. 19–31, 34 & 35)*. For Richards their virtues lay in the way these buildings derived *'their artistic character directly from the way the challenge of function is met, and all the qualities they have in common – forthrightness and simplicity, the emphasis on the basic geometry of architecture rather than the ritual of the historic styles, the use of building materials in a way that brings out most strongly their intrinsic qualities – are equally a product of the hard-headed relationship of ends and means that functionalism in this sense implies'* [16]. As Richards explained, the choice of de Maré, *'one of our best architectural photographers'*, was prompted by his book on canals, where he *'had already shown his interest in, and understanding of, early industrial architecture'* [17]. Although de Maré discussed his proposed itinerary and possible subjects with Richards and others, the choice of what to photograph was otherwise left to him. The resulting pictures were published in a special issue of the *Architectural Review* in July 1957, which was then reissued in a revised and expanded form in the following year as the book, *The Functional Tradition in Early Industrial Buildings*. For Richards, its author, the book was the realisation of a long-cherished ambition – the origins of which lay in the journeys he

[15] J. M. Richards, *The Functional Tradition in Early Industrial Buildings* (London: Architectural Press, 1958), p. 7. For an excellent analysis of de Maré and the functional tradition, see Andrew Higgott, *Eric de Maré: Photographer Builder with Light* (London: Architectural Association, 1990)
[16] *Ibid.*, p. 15
[17] *Ibid.*, p. 8

had made in the late 1930s with the artist John Piper, seeking out and photographing vernacular structures such as lighthouses, non-conformist chapels and mills that impressed by their simple propriety. Piper's unprepossessingly direct photographs subsequently appeared in two issues of the *Architectural Review*: *'Black and White: an Introductory Study of a National Design Idiom'* (July 1937) and *'The Nautical Style'* (January 1938). The latter in particular not only adumbrated many of the issues addressed by the post-war *Architectural Review* but also proved a significant influence on de Maré himself. It was this pre-War work that de Maré built upon and greatly expanded, finding many new examples of the functional tradition of which Richards and Piper had been unaware. One such example was the boat store in the Royal Naval Dockyard at Sheerness *(fig. 28)*, which was revealed to be a key early example of a multi-storey building with a complete iron frame. Out of the 265 photographs featured in *The Functional Tradition*, 202 were by de Maré, 21 by Richards and 15 by Piper, these two latter groups having been shot before the War. Richards was generous in his praise for de Maré's contribution — *'This is primarily a picture book, and is, therefore, more Eric de Maré's creation than mine. Its main interest and purpose lie in his splendid series of photographs'* [18]. These photographs have a freshness and vigour that empathise with the simple robust detailing and strength of character of the structures they record. In particular, de Maré's appreciation of the texture of materials — stone, brick

[18] J. M. Richards, *The Functional Tradition in Early Industrial Buildings* (London: Architectural Press, 1958), p. 7

and wood – gives to the photographs an almost tactile quality. Lovingly conceived and powerfully executed, the photographs were largely responsible for the book achieving what de Maré termed *'a certain succès d'estime'* [19].

The Functional Tradition recalled the fascination of pioneers of the Modern Movement such as Walter Gropius, Le Corbusier and Eric Mendelsohn for the primeval power and spare forms of American grain silos and other large industrial buildings but gave it a uniquely British flavour. Indeed, its publication should be seen as part of the concerted campaign by the *Architectural Review* and its acolytes (including Nikolaus Pevsner) to construct a respectable but above all indigenous ancestry for Modernism in Britain and thereby counter accusations that it was an essentially alien import imposed by a handful of émigrés on a country of which they had little understanding. In addition, it reflected the contemporary reawakening of interest in Britain and 'Britishness' and the desire to discover exactly what its inhabitants had fought to preserve, as well as the growth of industrial archaeology (a term which first came into common usage in the mid-1950s). Thus while de Maré's lens may have focused on the buildings of the past, the book had one eye fixed resolutely on the present. Its purpose was not simply to record but to suggest that here was a vernacular tradition that should serve as an inspiration to modern architects charged with the task of reconstructing post-War Britain.

[19] Eric de Maré, *The Nautical Style: an Aspect of the Functional Tradition* (London: Architectural Press, 1973), p. 7

The book, and especially de Maré's photographs, found fertile soil among that generation of architects trained mostly during or after the War, who deplored the sentimental populism of the Festival of Britain and the indulgent Romanticism of 'Scando'. They were eager instead to forge an architecture that was tougher and more rigorous. One such architect was Jim Stirling, whose flats at Ham Common, Richmond, London (1958) designed with his partner, James Gowan, drew their inspiration in part from Liverpool's brick warehouses that de Maré had photographed *(fig. 26)*. In a 1960 article, Stirling referred to the special issue of *Architectural Review* and proposed an expanded 'functional tradition' as a preferable alternative to modern architects' obsession with becoming either stylists or structural exhibitionists[20]. While Stirling was eager to distance himself from the emergent New Brutalism, it was on this movement, with its emphasis on honesty of structure and the use of materials 'as found', that de Maré's photographs had their most profound influence. For the former apostle of the New Empiricism this was not an altogether welcome development, de Maré dismissing New Brutalism as *'that perfect symbol of the dead end of puritanism'*[21].

De Maré continued to proselytise the virtues of the functional tradition in articles dealing with topics such as the structures of the iron and steel industries and power stations, which he regarded as in continuance of that tradition *(figs. 36 & 37)*. The

[20] *Perspecta*, no. 6, 1960, pp. 88–97
[21] *Architects' Journal*, vol. 121, 20 Jan. 1955, p. 104

latter resulted in one of his most striking images, a view of St Edward, Brotherton, dwarfed by the cooling towers of Ferrybridge B Power Station – a scene that quickly became popular with other photographers such as Magnum's Eve Arnold, who regarded it as the quintessential image of God dominated by Mammon. The cycle was completed with the publication by the Architectural Press in 1973 of *The Nautical Style: an Aspect of the Functional Tradition* – an addendum to Richards's work written and largely illustrated by de Maré. Harking back to Piper, the book was one of de Maré's most visually appealing, a delightful collage of views of lighthouses, sea-walls, piers, harbours, chains and the like. The text however struck a strong note of disillusionment. Modern architects had not heeded the functional tradition: '*With its graceless brutality, its faceless, joyless inhumanity, its boring mechanical repetitions, and its monotonous machine-made surfaces (often hideously streaked because not even weathered), most modern architecture has become thoroughly discredited*' [22]. Consequently, during his long career de Maré photographed relatively little contemporary architecture, although there were notable exceptions, among them the work of Howell Killick Partridge & Amis, which he greatly admired *(figs. 48 & 49)*.

Although de Maré's reputation as a photographer will remain indissolubly linked to the functional tradition, he photographed much else besides. Certain themes recur throughout this large

[22] Eric de Maré, *The Nautical Style: an Aspect of the Functional Tradition* (London: Architectural Press, 1973), p. 11

body of work. His association with the Architectural Press and in particular his close friendship with Gordon Cullen (townscape's chief proponent, who had begun working for the Press in 1946) fostered his interest in townscape and in bringing visual coherence to the norm of urban clutter. Cullen, no mean photographer himself, illustrated several of de Maré's articles and books with his highly distinctive drawings and, for his part, de Maré photographed many instances of what he regarded as sensitive civic design, concentrating on subjects such as street furniture, paving and changes in level. A good example is his shot of the south front of the Royal Palace, Stockholm *(fig. 3)* taken with a twin-lens Rolleicord camera which, being held at waist level, tended to accentuate what de Maré referred to as 'floorscape'. Another recurrent theme is London and the Thames, which he wrote about at length, perhaps most interestingly in a special number of the *Architectural Review* in July 1950. Through his photographs and Cullen's drawings, this issue persuasively advocated the preservation of the river as a *'linear national park'*. Such preservationist concerns (which underpin much of de Maré's photography) came increasingly to the fore during the latter part of his career when he photographed Victorian buildings at risk such as the Euston Arch *(fig. 60)* and J. B. Bunning's Coal Exchange, London, both of which were subsequently scandalously demolished. His fine series of photographs documenting the Royal Albert Bridge, London, the Ruskinian Oxford University Museum

and the Victorian cemetery at Norwood *(fig. 61)* were in a similarly preservationist vein and his camera proved an effective weapon in helping bodies such as the Victorian Society, founded in 1958, to combat hostility to nineteenth-century architecture.

The other main category into which de Maré's photographs fall may be described, for want of a better word, as 'topographical'. He travelled extensively, photographing scenes as diverse as fortifications in Malta *(fig. 73)*, Greek monasteries *(fig. 65)* and the ruins of Pompeii *(figs. 74 & 75)*. In this respect his work parallels that of another roving lensman, the American architect, critic and photographer George Kidder Smith (b. 1913), examples of whose imagery de Maré included in *Photography and Architecture* (1961) and whose books such as *Sweden Builds* (1950) and *Italy Builds* (1955) he praised as *'masterly'*. Masterly, too, is an epithet that could suitably be applied to the photographs specially commissioned from de Maré for George Henderson's *Chartres*, published by Pelican in 1968 *(figs. 66–68)*. These combine an unerring eye for the subtle details of the cathedral's statuary and other art works with analytically precise studies of its structure that are reminiscent of the American photographer Charles Sheeler's treatment of the subject in 1929.

De Maré's subject matter, allied to his photographic technique and philosophy, set him apart from mainstream professional

architectural photography. During the 1930s, particularly in the *Architectural Review*, the practice was established of using amateur 'snapshots' taken by members of the editorial staff or contributing journalists to illustrate polemical articles about the environment or to highlight previously neglected aspects of architectural heritage. These unpretentious images, usually reproduced small to fit more onto the page and thus give a sense of urgency to the case being propounded, co-existed alongside the glossy perfection of photographs by professionals such as Dell & Wainwright. This trend, exploring the world beyond publishable buildings, was continued during the 1950s by journalists such as Ian Nairn, but at the same time was greatly broadened and put on a professional footing by de Maré. He thus played an important role in assimilating photojournalistic methods and subject matter into professional architectural photography, a tendency that was to be vigorously pursued in the 1960s by photographers such as John Donat and 'shooting star' Tim Street-Porter, who used 35mm cameras that de Maré himself regarded as of limited value in architectural work. Nevertheless, his images retain that sense of campaigning vigour and were often also reproduced small-scale because they were usually designed to be read as part of an unfolding sequence and in close conjunction with the accompanying text. One should always be aware therefore of this loss of context even when marvelling at the unity of individual compositions.

Whereas most professional architectural photographers generally used larger cameras such as the Swiss-made Arca or Sinar, which took 5- × 4-inch cut film in holders and permitted all the usual movements such as the rising front and the swing back, de Maré preferred to work with smaller, less cumbersome formats. The first camera he used as a professional was a Rolleicord, a cheaper version of the twin-lens Rolleiflex, to which he soon graduated and with which he admitted he *got away with murder for years* [23]. The Rolleiflex took roll film and produced $2^1/4$-inch square negatives, which some architectural photographers such as Henk Snoek scorned as antipathetic to the proportions found in architecture, but which de Maré strongly favoured. He then increasingly used $2^1/4$- × $3^1/4$-inch roll film in a Linhof Super Technika, always ensuring he took two roll film holders taking 120 size film with him on jobs so that he could switch from fast to slow film or from black and white to colour without having to use a whole roll first. The Linhof also had the advantage that, in order to switch between horizontal and vertical framing, only the film holder, rather than the whole camera, had to be turned around.

De Maré's choice of equipment was governed by his photographic vision, which though essentially classical – *'behind ... casual effect lies strong, whole composition'* [24] – was nevertheless far removed from the studied abstraction of most professionals. If, for example, one compares his work to that of Dell & Wainwright (whose irresistibly

[23] *Architects' Journal*, vol. 147, 17 Jan. 1968, p. 195
[24] Eric de Maré, *Photography*, 7th Edn (Harmondsworth: Penguin Books, 1980), p. 65

seductive images full of strident contrasts, angular geometry and austere precision set the tone for much post-War photography, including that of Henk Snoek and Richard Einzig) the difference in outlook becomes readily apparent. Even to the consternation of Jim Richards, Dell & Wainwright totally expunged the human presence from their pictures. The houses they photographed became literally machines for living in, unsullied realisations of the perfection dreamed of by the architect at his drawing board. By contrast, de Maré's photography is imbued with an unquenchable humanism. Normally viewed walking towards the centre of the scene to lead the eye into the picture, people frequently appear in his photographs, but even when they do not, the indelible evidence of their habitation or craftsmanship remains. This humanism is further enhanced by de Maré's often quirky sense of humour and irony. Indeed, his approach seems to take its cue from an author he was fond of quoting, Geoffrey Scott, who, in his *The Architecture of Humanism*, wrote, *'The art of architecture studies not structure in itself, but the effect of structure on the human spirit'* [25]. The technically perfect but essentially soulless image, so evident in much architectural photography today, had no place in de Maré's *oeuvre*. Nor, too, were the buildings he captured photographed in isolation but placed firmly in the environment with which they interacted.

'A picture will not tell its story half so effectively', de Maré wrote, *'if it is not held together by a firm, simple, structural composition which*

[25] Geoffrey Scott, *The Architecture of Humanism* (London: Constable & Co., 1914), p. 120

makes a whole' [26]. For de Maré the essential attributes of such composition were contrast, repetition, balance, climax and cohesion. De Maré's pictures therefore have an architectonic quality that is further emphasized by his use of certain key compositional devices. Among these may be mentioned the way in which significant details are isolated in close-up to revealing effect; the way in which spatial depth is powerfully conveyed through converging lines or receding planes or, more especially, by the inclusion in the foreground of an object very close to the camera; an emphasis on asymmetry rather than the head-on elevational approach preferred by some architectural photographers; the juxtaposition of elements within the frame to make a comment, seen for example in his photograph of Constitution Arch, Hyde Park Corner *(fig. 57)*, where the soldier's memorial in the foreground suggests the cost which must be paid for such military vainglory; and, last but not least, a passion for trees that he described as *'our new form of baroque decoration'* [27] and used as an animating counterbalance to the clean lines of modern architecture. De Maré's classical sense of composition certainly did not preclude ostensibly 'romantic' views, such as the railway viaduct at Stockport seen in the rain *(fig. 33)*, nor his strongly sensual treatment of texture.

De Maré's work above all exemplifies his strong belief in the visual kinship between architecture and photography. Echoing Le

[26] Eric de Maré, *Photography and Architecture* (London: Architectural Press, 1961), p. 13
[27] *Ibid.,* p. 40

27

Corbusier's famous dictum that architecture is *'the masterly, correct, and magnificent play of masses brought together in light'* [28], de Maré described photography as *'building with light'* [29] and emphasized the structural similarities between the two disciplines: *'both are concerned with constructing forms, lines, tones, textures, and possibly colours, into a sculptural unity'* [30]. His point has been underlined by the number of other British architectural photographers since World War II who have had architectural training. These include John Donat, Richard Einzig and Richard Bryant. For de Maré architectural photography could be divided into three broad but not necessarily watertight categories. Firstly, there was the record or survey photograph, where the aim was the provision of accurate documentary information. Secondly, there was what he termed *'the illustration'*, which in its combination of satisfactory record with aesthetically pleasing picture encompassed most professional architectural photography. Thirdly, there was for de Maré the most exciting and creative category, *'the picture or architectonic design'*, where the subject might be quite ordinary and possess little architectural value in itself, but even so the photographer had managed to create out of it a work of visual art. De Maré's photographs were often reproduced in an *Architectural Review* series entitled *'The Exploring Eye'*. The phrase is wholly appropriate as it will be this capacity to discern 'architecture' where none was intended, combined with his ability to throw fresh light on familiar subjects, which will prove his most enduring legacy.

[28] Le Corbusier, *Towards a New Architecture*, trans. Frederick Etchells (London: John Rodker, 1927), p. 29

[29] *Architecture and Building*, vol. 33, Oct. 1958, p. 386

[30] Eric de Maré, *Photography and Architecture* (London: Architectural Press, 1961), p. 19

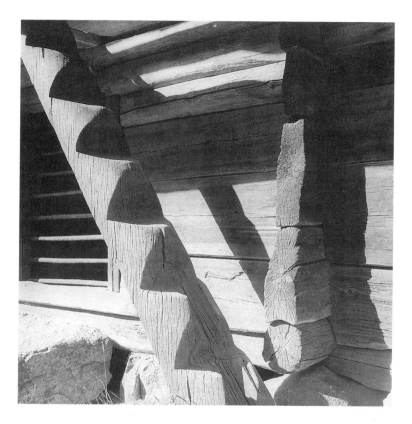

fig. 1

Medieval notched timber ladder,
Mora farmstead,
Skansen Open-Air Museum,
Stockholm (1952)

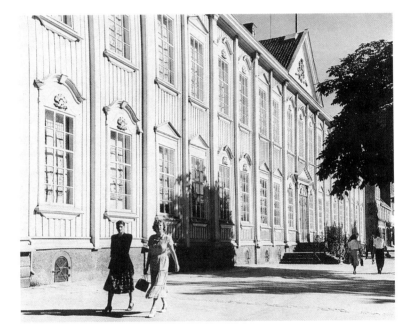

fig. 2

**Stiftsgaarden,
Trondheim** (1952)

Architect:
General Frederick von Krogh

fig. 3

**South entrance to the Royal Palace
with the Storkyrkan, the Great Church,
in the background, Stockholm** (1952)

Architects:
Nicodemus Tessin the Younger / C.W. Carlberg

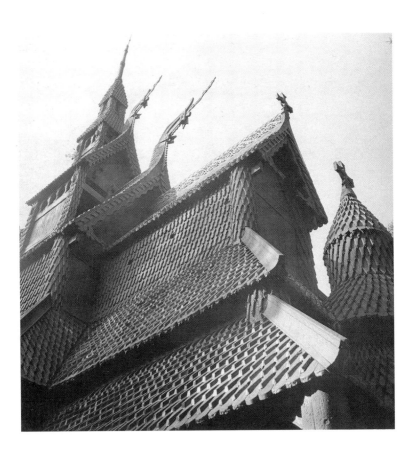

fig. 4

**Stave church,
Borgund, Norway** (1959)

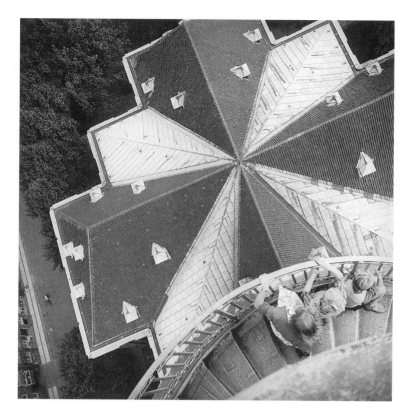

fig. 5

**St Saviour's Church,
Copenhagen** (1956)

Architect:
Lambert van Haven and Lauritz de Thurah

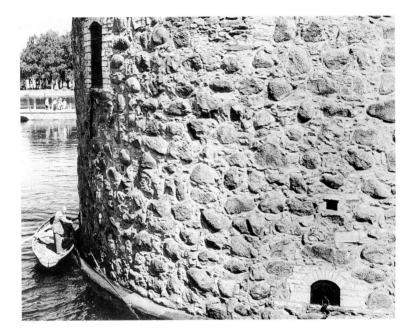

fig. 6

**Vadstena Castle,
Sweden** (1952)

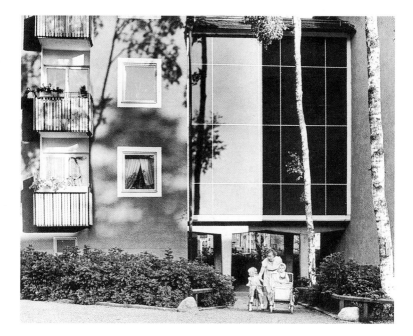

fig. 7

**Flats at Blackeberg,
Stockholm** (1955)

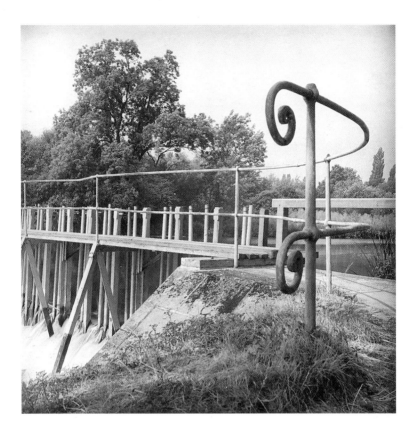

Metal pipes and stanchions of bridge
(1948)

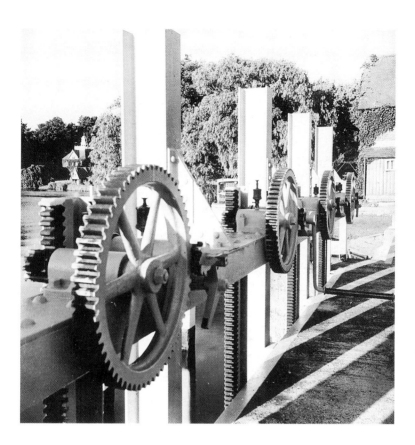

fig. 9

Gearing of weir paddles at Goring Lock
(1950)

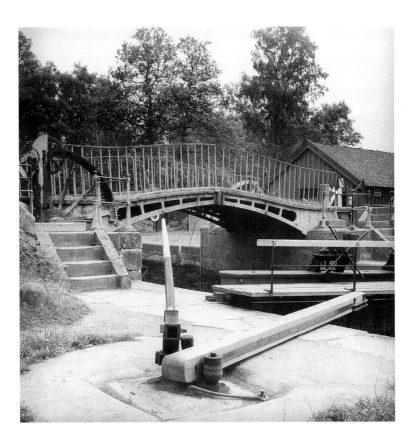

fig. 10

**The English bascule bridge across the
Göta Canal at Forsvik, Sweden** (1956)

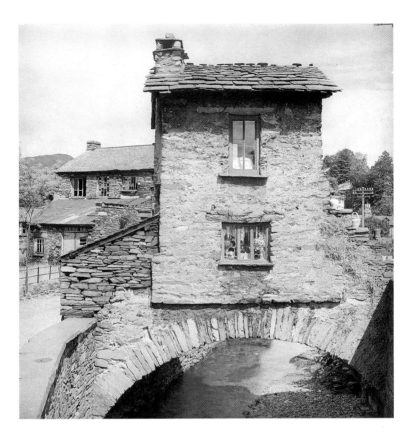

fig. 11

Bridge House, Ambleside
(1954)

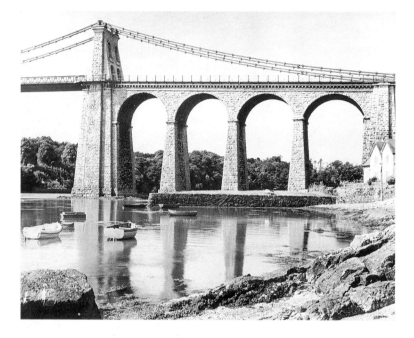

fig. 12

**The arched approach on the Anglesey
side of the Menai Bridge, Caernarvonshire** (1954)

Designer:
Thomas Telford

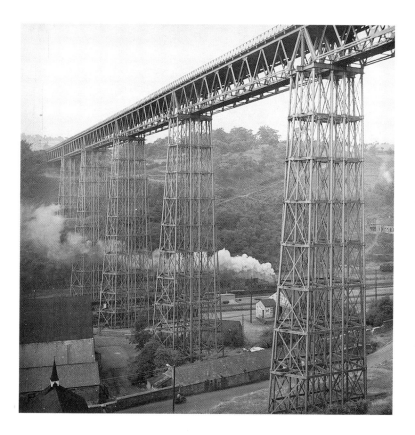

fig. 13

Crumlin Viaduct, Ebbw Vale
(1954)

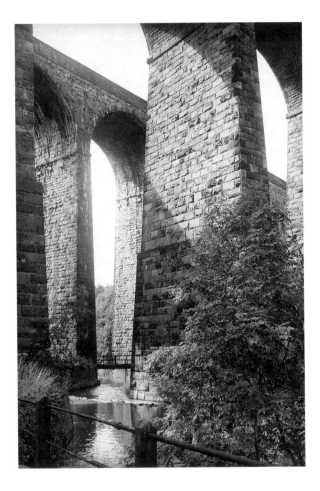

fig. 14

Chapel-en-le-Frith Viaduct
(1954)

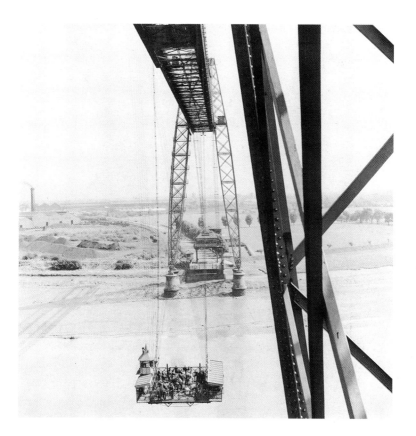

Newport Transporter Bridge,
Monmouthshire (1954)

Designers:
R. H. Haynes and F. Arnodin

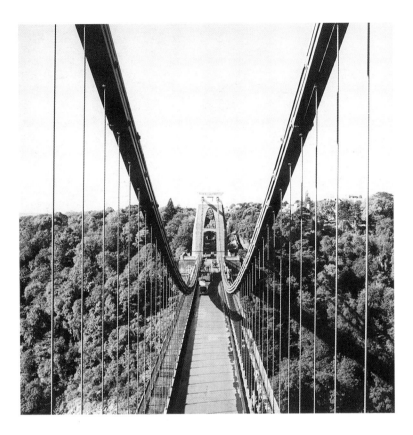

fig. 16

**Clifton Suspension Bridge,
Bristol** (1954)

Designer:
Isambard Kingdom Brunel

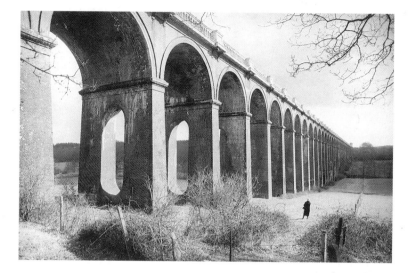

fig. 17

**Balcombe Viaduct,
Sussex** (1954)

45

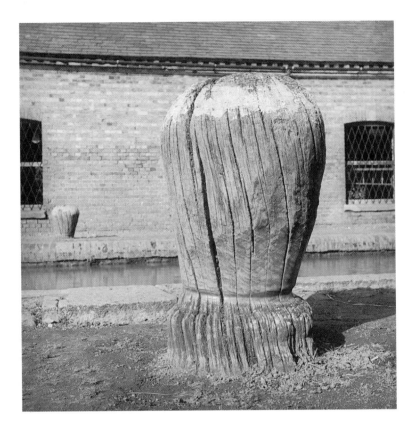

fig. 18

Canal bollard
(1949)

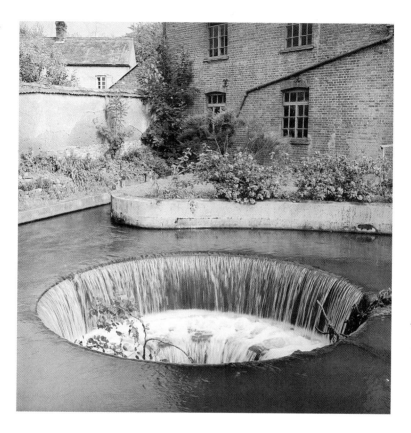

fig. 19

Tumbling weir at an eighteenth-century serge mill,
Ottery St Mary, Devon (1956)

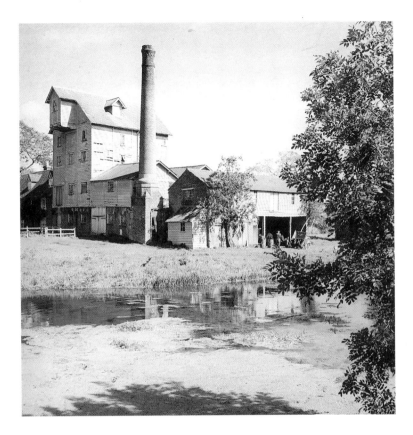

fig. 20

**Former watermill then farmhouse,
Chilham, Kent** (1956)

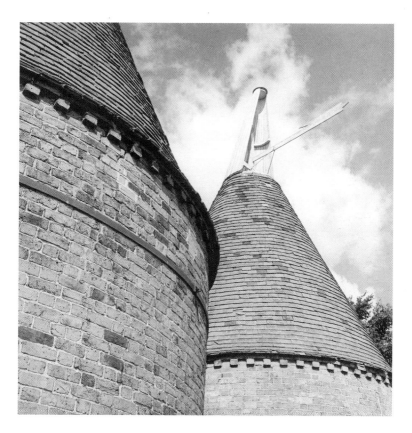

fig. 21

Oast house drying kilns, Kent
(1956)

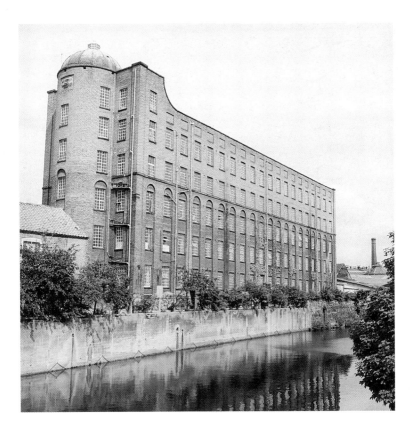

fig. 22

**Norwich Yarn Company,
Norwich** (1956)

Builders/Designers:
Dawkins & Cattermole

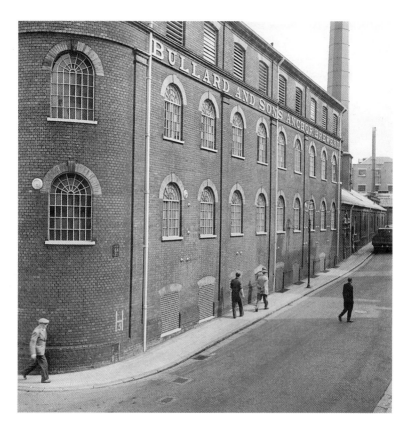

fig. 23

**Bullard's Anchor Brewery,
Norwich** (1956)

51

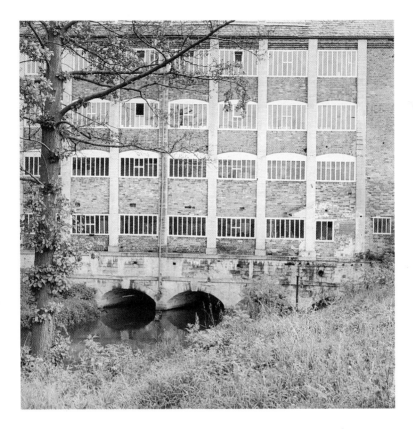

fig. 24

**Stanley Mill, Stonehouse,
Gloucestershire** (1956)

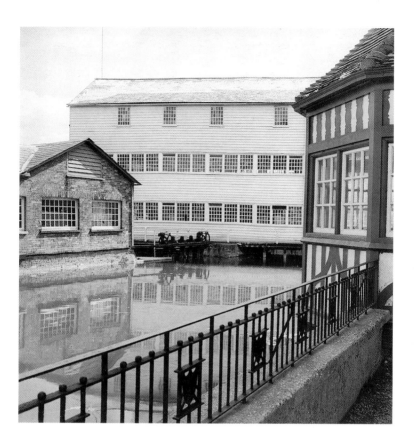

fig. 25

**Halstead Mill,
Essex** (1956)

53

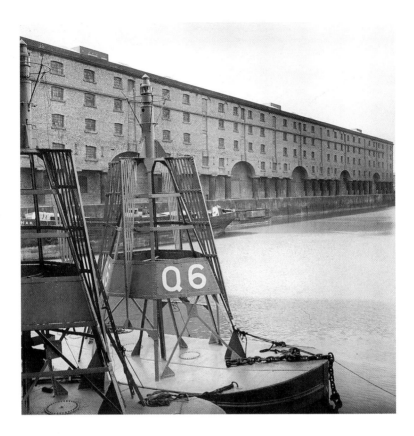

fig. 26

**Albert Dock,
Liverpool** (1956)

Designer:
Jesse Hartley

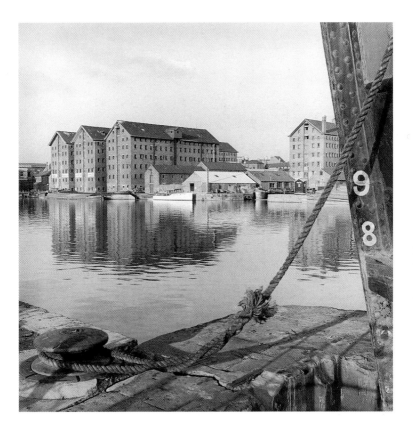

fig. 27

Gloucester Docks
(1956)

55

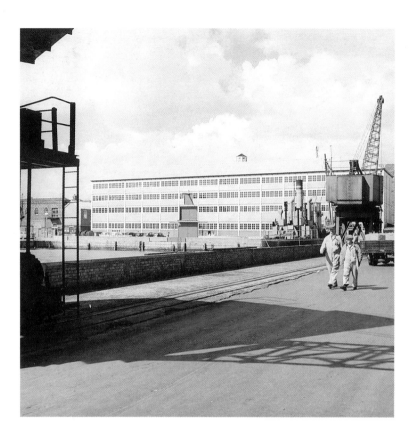

fig. 28

**Boathouse, Royal Naval Dockyard,
Sheerness, Kent** (1956)

Designer:
Colonel G. T. Greene

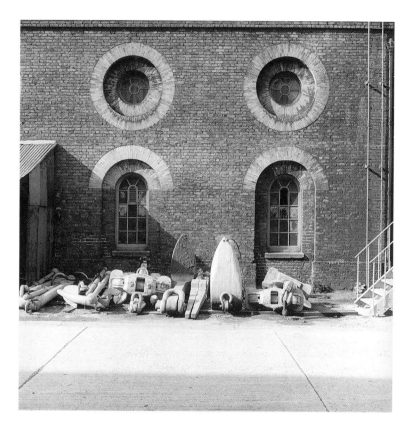

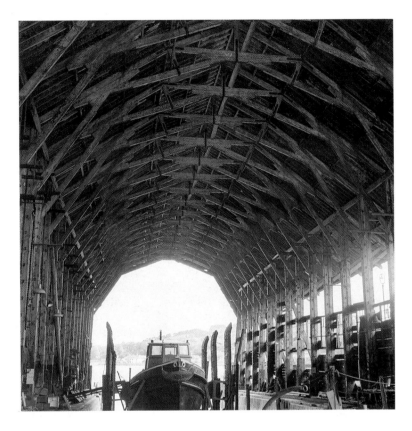

fig. 30

**Slip no. 1, Royal Naval Base,
Devonport, Plymouth** (1956)

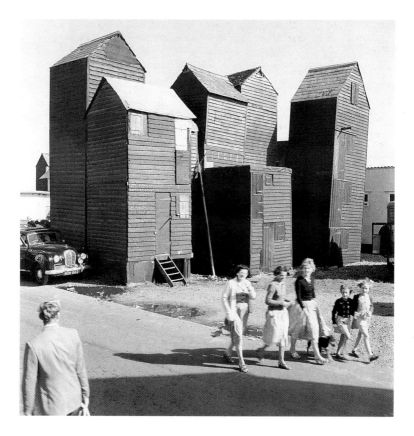

fig. 31

'Skyscraper' sheds on the beach at Hastings
(1956)

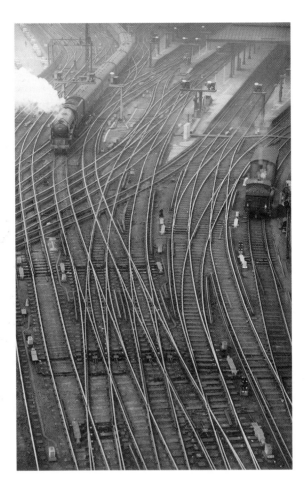

fig. 32

Railway lines
(1950s)

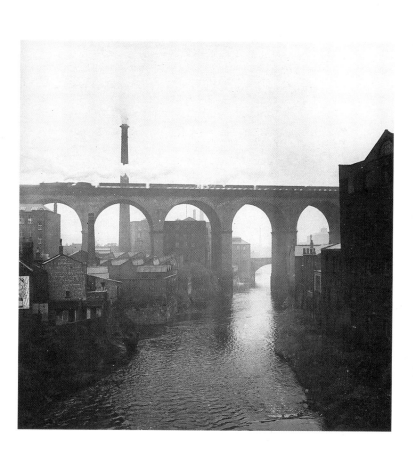

fig. 33

**Stockport Viaduct,
Cheshire** (1954)

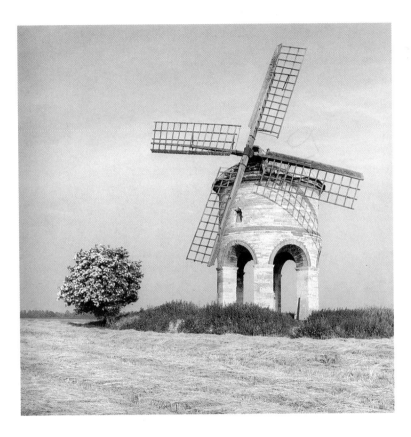

fig. 34

**Chesterton Mill,
Warwickshire** (1956)

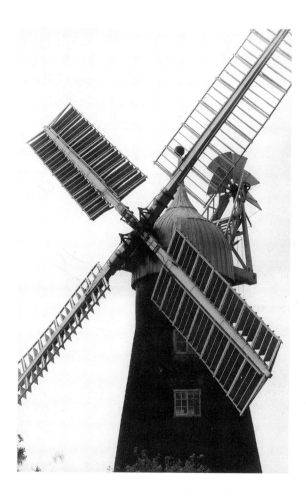

fig. 35

Subscription Mill, North Leverton,
Nottinghamshire (1956)

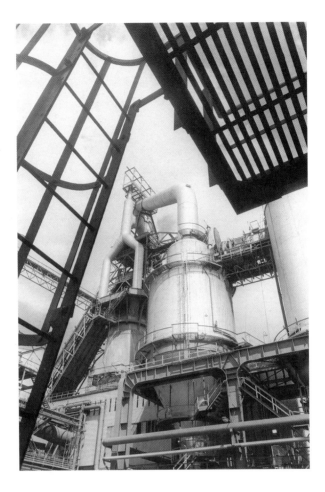

fig. 36

**No. 5 blast furnace and ancillary plant,
Margam & Abbey Works
of the Steel Company of Wales** (1961)

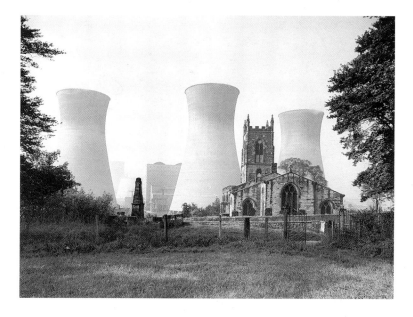

fig. 37

**St Edward, Brotherton, with Ferrybridge B
Power Station behind** (1960s)

Designers:
Pritchett & Son / Watson & Coates

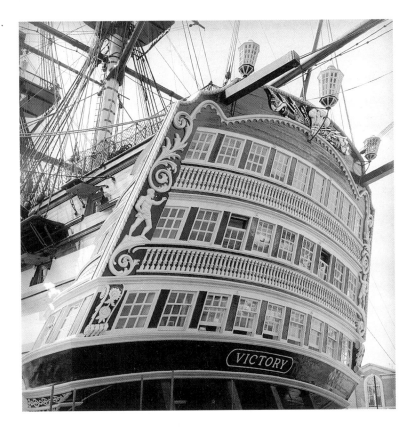

fig. 38

H.M.S. Victory
(1973)

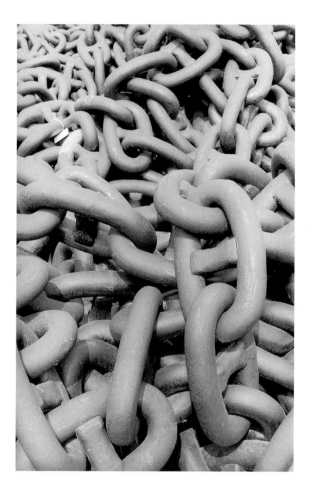

fig. 39

Anchor chain
(1973)

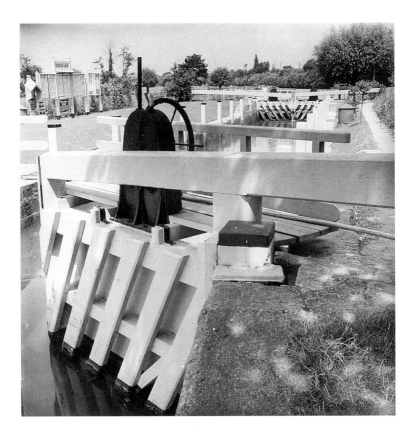

fig. 40

Cleeve lock on the Thames
(1950)

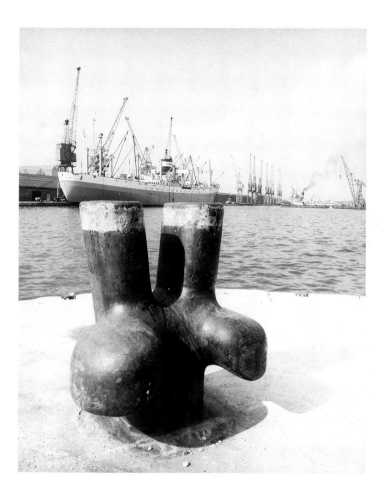

fig. 41

Bollard, London Docks
(1963)

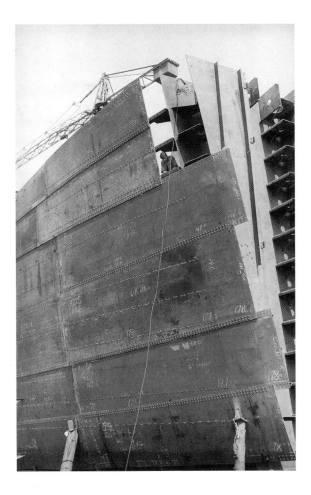

fig. 42

Shipbuilding on the Clyde
(1973)

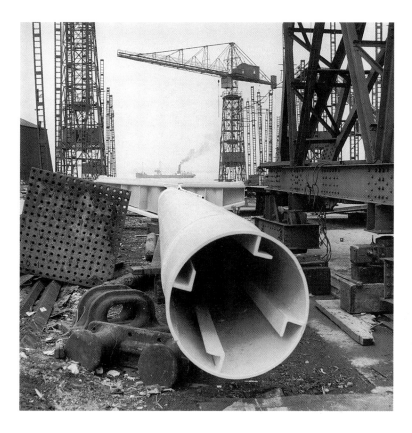

fig. 43

A shipyard on the Clyde
(1973)

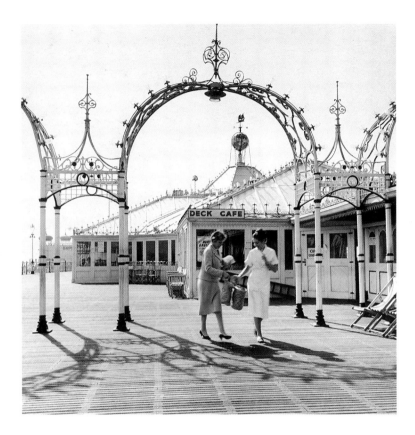

fig. 44

**Palace Pier,
Brighton** (1960s)

Designer:
R. St Moore

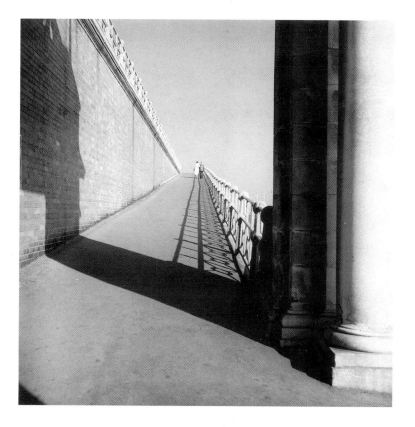

fig. 45

**The Esplanade,
Brighton** (1960s)

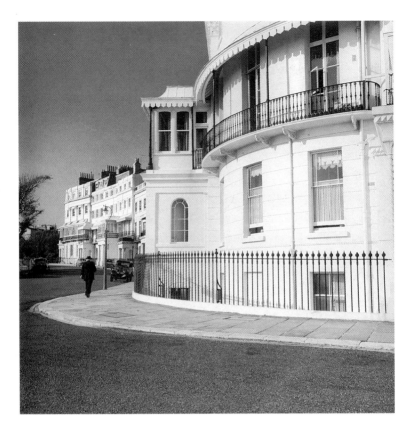

fig. 46

**Lewes Crescent,
Brighton** (1961)

Architects:
Amon Wilds and Charles Busby

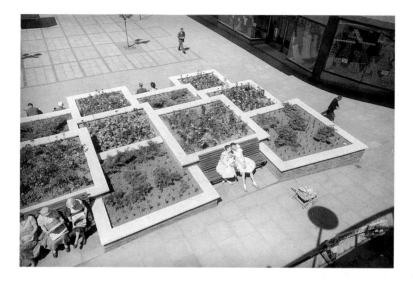

fig. 47

**Shopping precinct,
Coventry** (1960s)

Architect:
Arthur G. Ling, City Architect & Planning Officer

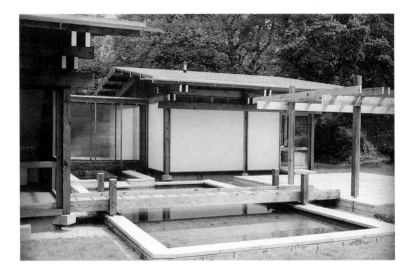

fig. 48

**North House,
Bromley, London** (1964)

Architects:
Howell Killick Partridge & Amis

fig. 49

**House, Little Ruffo,
Trebarwith Sands, Cornwall** (1962)

Architects:
Howell Killick Partridge & Amis

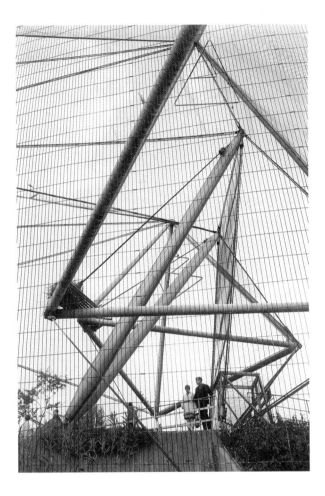

fig. 50

**Snowdon Aviary,
London Zoo** (1965)

Designers:
Lord Snowdon with Cedric Price and Frank Newby

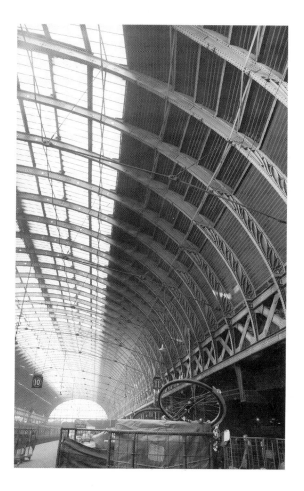

fig. 51

**North train shed,
Paddington Station, London** (1960s)

Designers:
Isambard Kingdom Brunel and Matthew Digby Wyatt

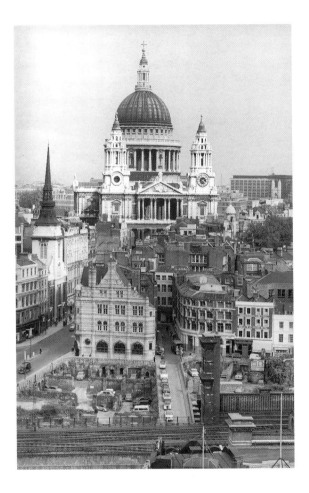

fig. 52

**St Paul's Cathedral taken from
the steeple of St Bride's, London** (1960s)

Architect:
Sir Christopher Wren

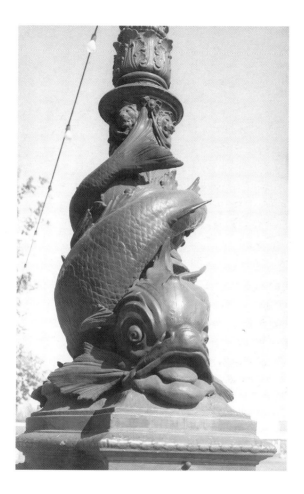

**Dolphin lamppost,
London** (1958)

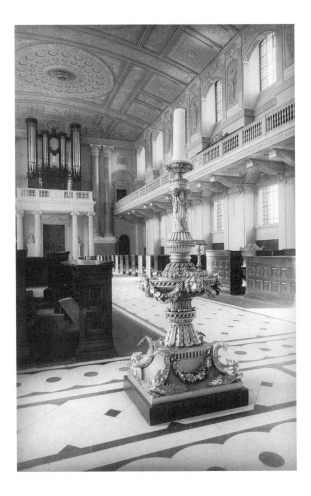

fig. 54

**Chapel, Royal Naval College,
Greenwich, London** (1960s)

Architect:
James Stuart

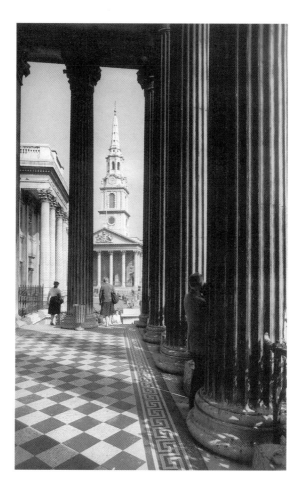

fig. 55

**St Martin-in-the-Fields, Trafalgar Square,
seen through the columns of the porch
of the National Gallery, London** (1975)

Architects:
James Gibbs / William Wilkins

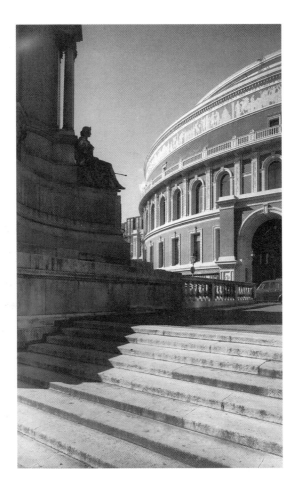

fig. 56

**London's Royal Albert Hall
with the base of the Albert Memorial
in the foreground** (1960s)

Architects:
Captain Francis Fowke / Sir George Gilbert Scott

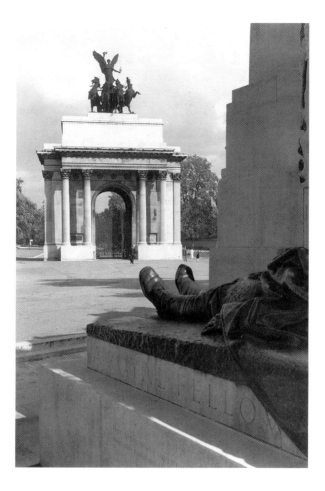

fig. 57

**Constitution Arch,
Hyde Park Corner, London** (1960s)

Architect:
Decimus Burton

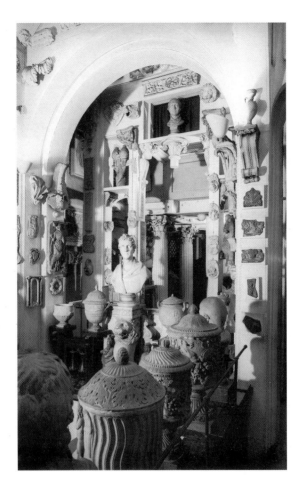

fig. 58

**The Dome area,
Sir John Soane's Museum,
13 Lincoln's Inn Fields, London** (1960s)

Architect:
Sir John Soane

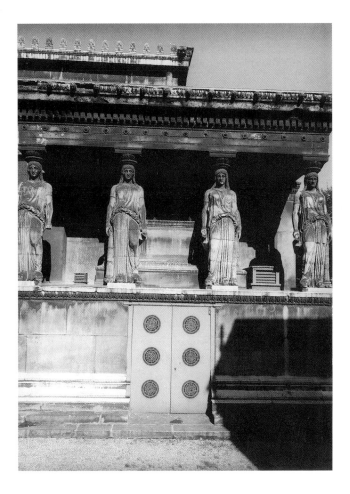

fig. 59

**Caryatid porch, St Pancras Church,
London** (1960s)

Architects:
William and Henry William Inwood

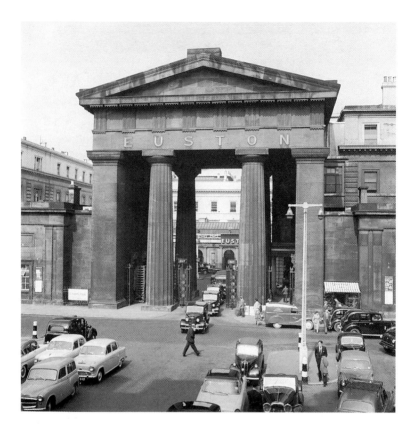

fig. 60

**Euston Arch,
London** (1961)

Architect:
Philip Hardwick

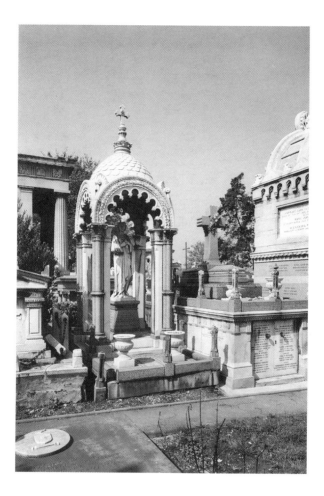

fig. 61

**Canopied monument to T.E. Schilizzi
in the Greek cemetery,
West Norwood Cemetery,
London (1970)**

fig. 62

**Royal Dairy at Frogmore,
Windsor** (1969)

Architect:
John Thomas

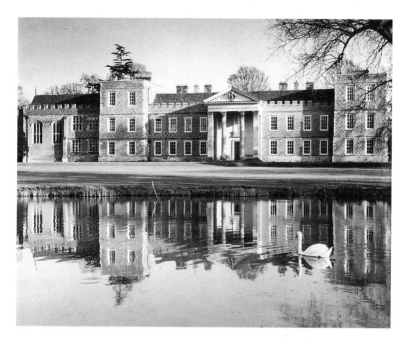

fig. 63

**North front, The Vyne,
near Basingstoke** (1959)

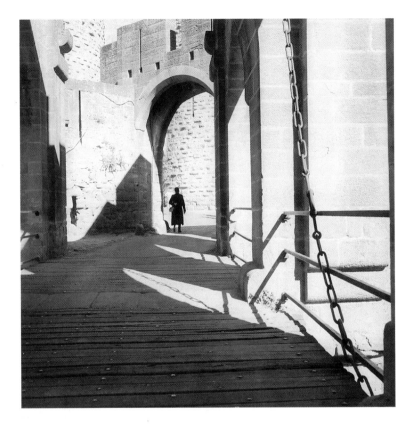

fig. 64

**Ramparts,
Aigues-Mortes** (1950s)

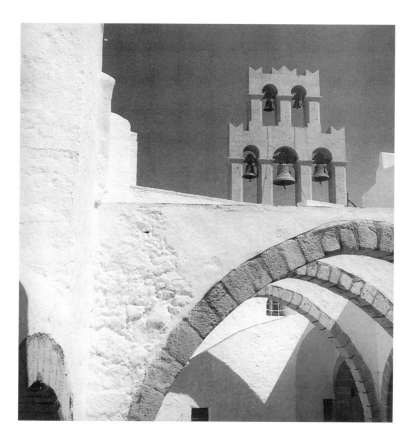

fig. 65

**Monastery,
Patmos** (1950s)

93

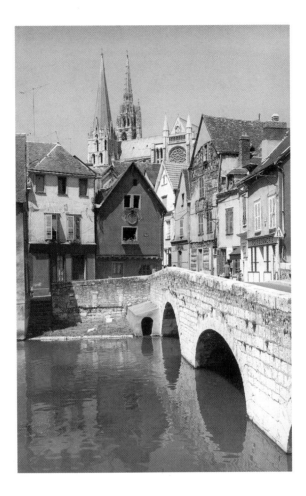

fig. 66

Chartres Cathedral from the south
(1968)

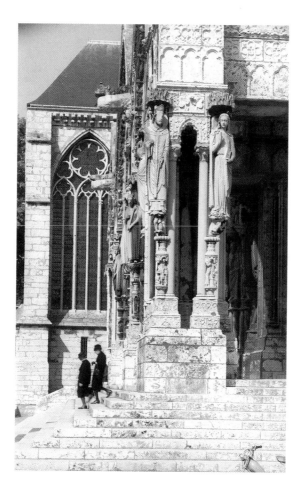

fig. 67

**Porch, north transept, Cathedral,
Chartres** (1968)

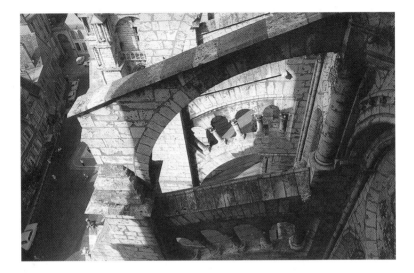

fig. 68

**Fliers of buttresses of the nave,
Cathedral, Chartres** (1968)

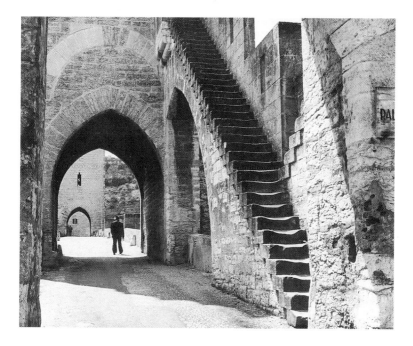

fig. 69

**Pont Valentre, Cahors,
France** (1950s)

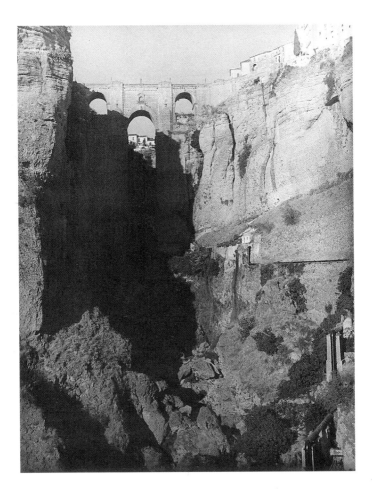

fig. 70

Ronda,
Spain (1937)

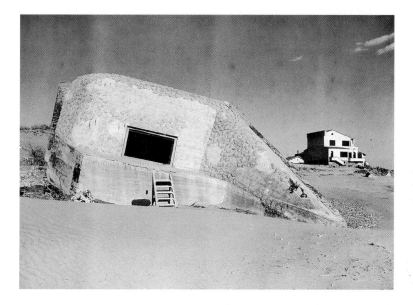

fig. 71

**German fortifications,
Agde, France** (1960s)

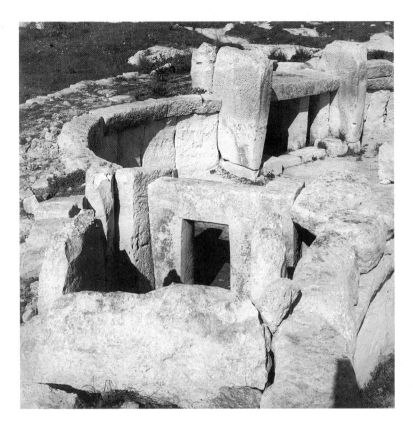

fig. 72

**Megalithic temple,
Malta** (1957)

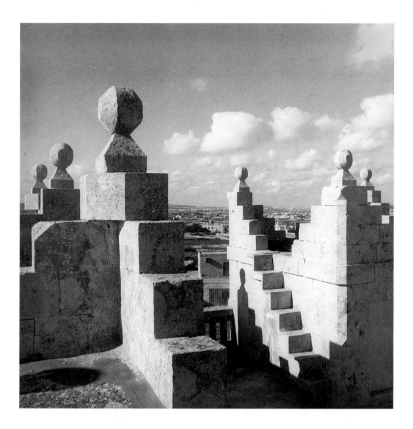

fig. 73

Tower of an old defended palace on Malta
(1957)

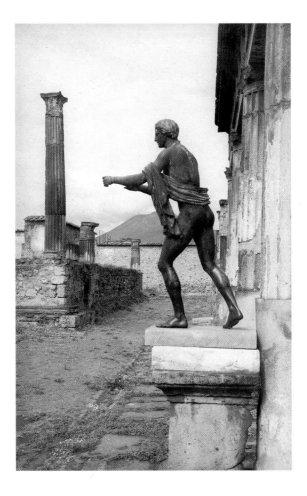

fig. 74

Temple of Apollo,
Pompeii (1976)

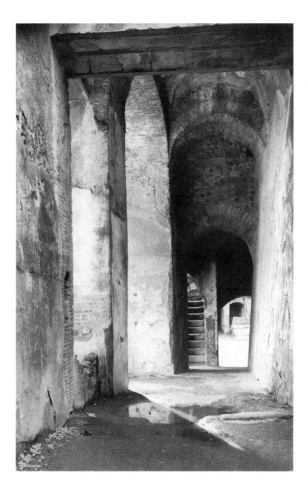

fig. 75

**Foyer between the two Roman theatres
in the ruins of Pompeii** (1976)

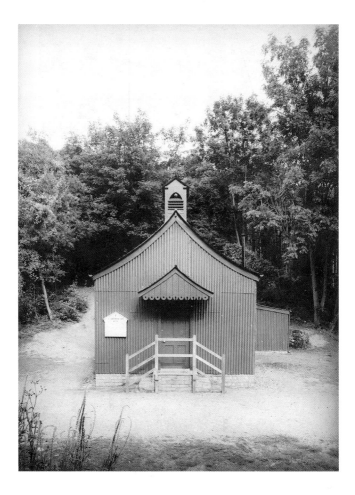

fig. 76

**St Chad's Mission Chapel,
Ironbridge** (1960s)

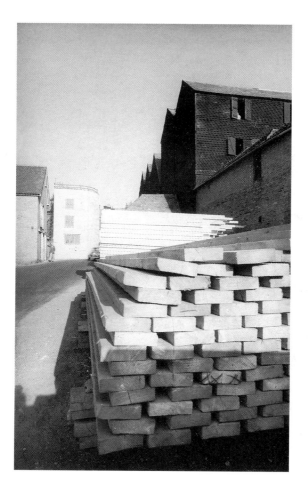

Rye (1961)

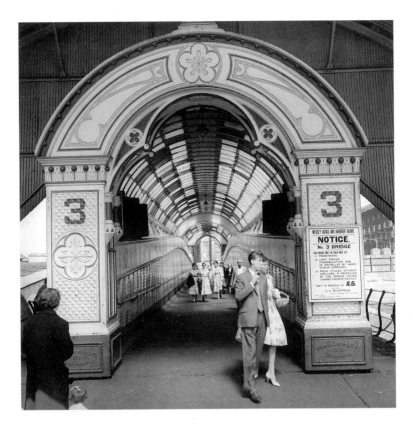

fig. 78

**Mersey Docks and
Harbour Board's no. 3 bridge,
Liverpool** (1958)

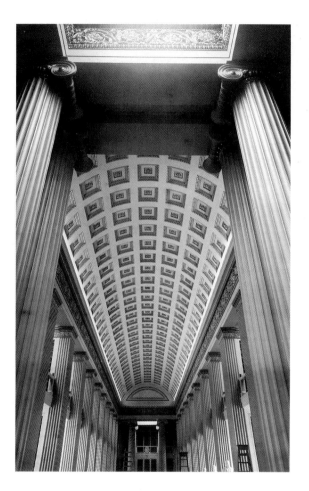

fig. 79

**Signet Library, Parliament Square,
Edinburgh** (1975)

Architect:
William Stark

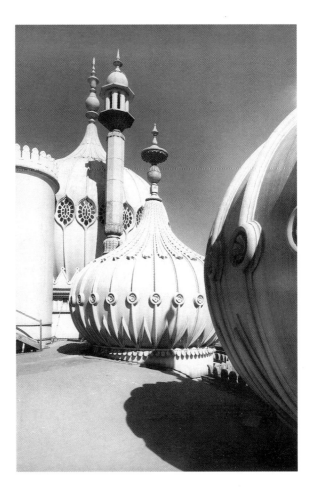

fig. 80

**Royal Pavilion,
Brighton** (1960s)

Architect:
John Nash

Also in this series

John Maltby

by Robert Elwall

John Maltby (1910–80) rose to prominence during the thirties, when architecture and the camera were still in the first flush of love and when the International Style was at the height of fashion. In the same way as Claude Gravot was the favoured photographer of Le Corbusier, so Maltby was closely allied to Lubetkin, one of the great modernist émigré architects working in Britain at the time. Maltby also recorded the fashionable Art Deco style with a lucrative commission for Odeon cinemas. After World War II and in stark contrast to the opulence of the Art Deco cinemas, his photographs of Alison and Peter Smithson's Hunstanton School were admired and reproduced around the world, while his commercial work helped to spread the popularity of the Contemporary look.

Published by RIBA Publications, June 2000
ISBN 1-85946-082-8 Product Code: 21002
Pb 110pp 80b/w photos